READY TO PAINT

Landscapes in Oils

WITHDRAWN

SEARCH PRESS

First published in Great Britain 2009

Search Press Limited
Wellwood, North Farm Road,
Tunbridge Wells, Kent TN2 3DR

Text copyright © Noel Gregory 2009

Photographs by Debbie Patterson at Search Press studios, except for page 8, by Roddy Paine Photographic Studios

Photographs and design copyright © Search Press Ltd. 2009

ISBN: 978-1-84448-364-8

The Publishers and author can accept no responsibility for any consequences arising from the information, advice or instructions given in this publication.

Suppliers
If you have any difficulty obtaining any of the materials and equipment mentioned in this book, please visit the search press website:
www.searchpress.com

Publisher's note
All the step-by-step photographs in this book feature the author, Noel Gregory, demonstrating his oil painting techniques.
No models have been used.

To my parents Leonard and Olive Elsie Smith who put up with me during my mad art school days, who both thought being an artist wasn't a real job, but encouraged me anyway. I miss them dearly.

Acknowledgements
To my partner Sue, who has given me all the time I need to paint and indulge in my passion for shell collecting and diving world wide.

Page 1:
My Village
200 x 100cm (78¾ x 39½in)

This large canvas was produced on the spot from my village in Southern Spain. This is a particular favourite landscape painting of mine that works well because of the subject matter and strong tonal contrast.

Opposite:
Rhododendron Bridge
100 x 65cm (39½ x 25½in)

This bridge has appeared in many of my paintings. In this case, it is a composite made from several photographic images. As long as some care is taken when comparing the scales between the various sources, and that you make sure the shadows are facing the same way, the use of different sketches or photographs in one picture is a valuable tool in image-making.

Printed in China

Contents

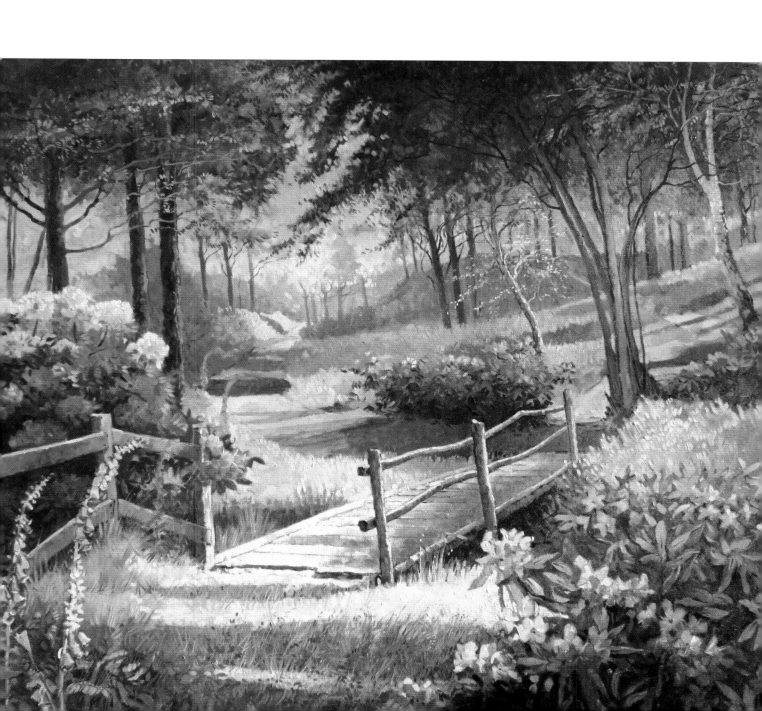

Introduction

Any help one can get in achieving a satisfying result in painting has to be a good idea. The help of a predetermined line that can be transferred on to canvas is a godsend in the production of a painting.

This book provides stage-by-stage instructions and information on the colours used, and it also provides the images as pull-out tracings for you to use and re-use. This also means that you do not need concern yourself with composition, allowing you to paint these pictures without the worry of whether or not the image is correct. However, although you have the lines in the right place, it still falls to you to have the talent to interpret these lines.

One thing I do ask of you is not to treat these image lines as the exact edges of the image: to do so would leave you with a flat, uninteresting painting. It is my hope that these subjects will be of considerable help to you in all your future painting, and you go on to produce your own compostions and paintings.

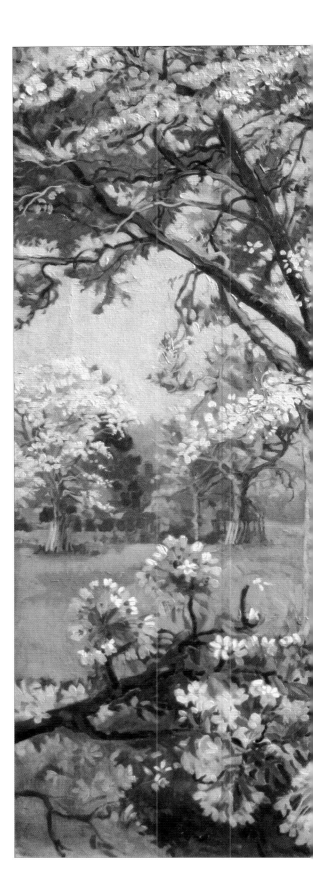

TRACING

1

Spring Lambs

80 x 50cm (31½ x 19¾in)

Spring means landscape painting to me, for there is always a special feeling of excitement about all these fresh colours and new lease of life. The picture was first painted thirty years ago and the original had a girl under the large tree. After several years of not liking the finished result, I took some photographs of sheep and added them instead of the figure, making it in my mind a much better painting.

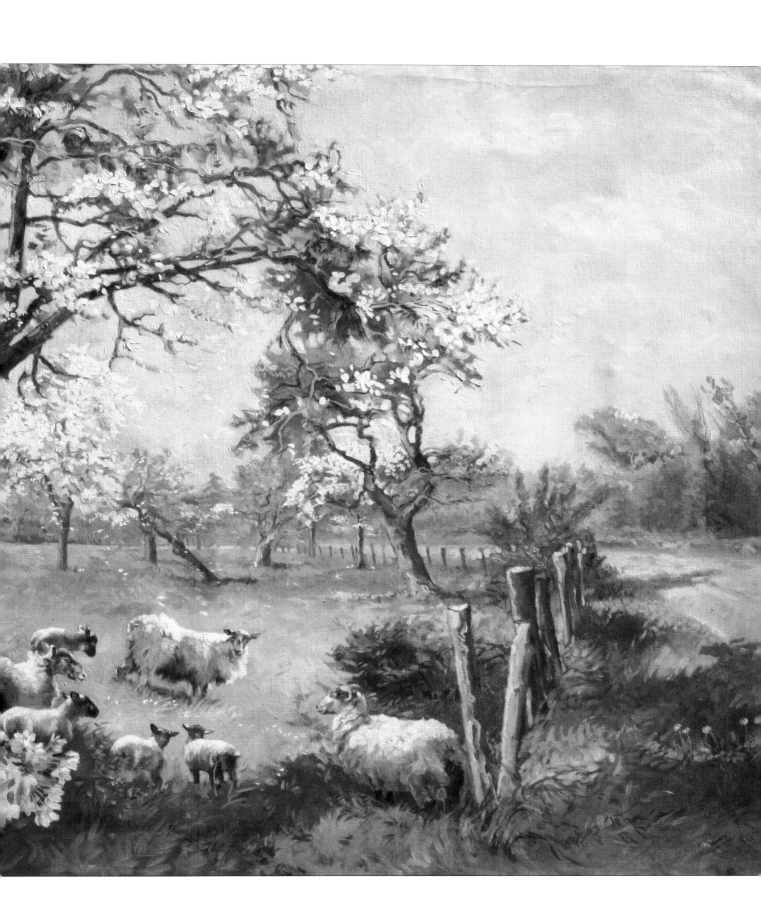

Materials

Paints

Every artist has a palette of pigments that works for them. This is the collection of colours that I use: it has been selected over many years and although you may not use them all and may want to add other paints, it is a useful if not an essential range.

Titanium white Probably the best modern white, replacing flake white which is no longer being produced.

Viridian This is a strong colour, useful for making a huge range of greens for the landscape painter.

Sap green A natural and subtle green for trees and foliage.

Lemon yellow A gentle and strong primary for a huge range of mixes.

Cadmium yellow A strong and powerful yellow and a favourite of Monet for its warmth in mixing.

Cadmium orange One of Monet's favourite hues, and I one that I also find very useful.

Cadmium scarlet A good primary red, this is essential for mixing a full range of reds.

Winsor red A strong red that is especially useful for landscapes.

Alizarin crimson Transparent pigment and extremely useful for flowers etc.

Permanent mauve A good colour that gives another range of warm hues. I include it because it is impossible to mix from other colours with any intensity.

Cobalt blue Another of Monet's favourites, this gives the most beautiful of blues and a good mixer with other colours. It is also useful for skies.

French ultramarine An essential blue and one that is particularly useful for skies.

Burnt umber One of the earth colours that I feel is a must for any palette, burnt umber darkens and reduces the intensity of all the other colours.

Burnt sienna Another earth colour, this gives a warmer hue than burnt umber. It is also useful for making more subdued mixes.

Brushes

The brushes used by an artist are a very personal choice and your decision should be made after some time gaining experience.

Pictured opposite are brushes that make a good starter set. Most are flats or brights (flat brushes with shorter bristles) with some small rounds for detail work. This particular collection of brushes is especially useful for the small works discussed in this book. From left to right:

Size 4 Cotman 111 round A good general drawing brush with excellent area coverage.

Size 8 Artists' hog short flat A brush used for covering large areas when starting a painting.

Large fan brush This is generally used at the end of a painting to soften and blend colours on the canvas.

Size 4 Artists' hog short flat Used for general work, covering areas that are too small for the size 8, but too large for the size 2.

Size 2 Artists' hog short flat Again used for general work, this is especially suited to details.

Size 1 sable round A brush used near the end of a painting for finishing and detail work. A size 2 round or size 1 flat are good alternatives.

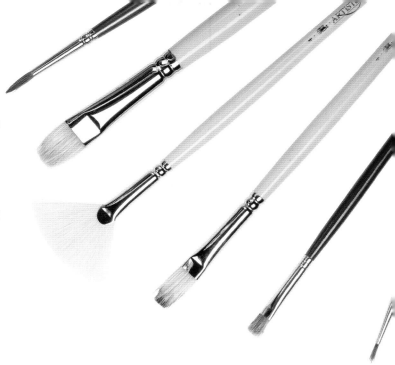

Canvas

Any canvas or canvas board may be used in the reproduction of the images in this book. Please buy the best you can afford – some cheap canvases can hinder rather than help with your results.

Your canvas must be the same size as the tracing or a board that can be cut to the required size.

Other materials

Linseed oil This is one of the best oils used for thinning oil paint to the required consistency for your painting. Always try to use artists' quality: commercial oil is too thick for good results.

White spirit and **turpentine** Also essential for thinning your oil paints, both will dilute the pigment to thin washes. White spirit is cheaper, while turpentine is perhaps better for professional results. An added bonus is that it will clean everything after your work for the day is finished.

The smell of turpentine is not for everybody. Low odour alternatives are available from most artists' suppliers and this will help eliminate smells if you paint indoors.

Kitchen paper Whether used to clean brushes or remove paint from your hands or your work, kitchen paper has many uses.

4B pencil This is a good pencil grade for transferring your image from the tracing to the canvas, although any soft pencil will do.

Sharpened brush handle Any brush can be used as a signing tool or fine line marker if the end is sharpened with a knife.

Small pots to hold mediums Any smallish container may be used for this purpose, and these china utensils are ideal. Alternatively, metal containers that fit on to palettes – called dippers – may be obtained in several sizes.

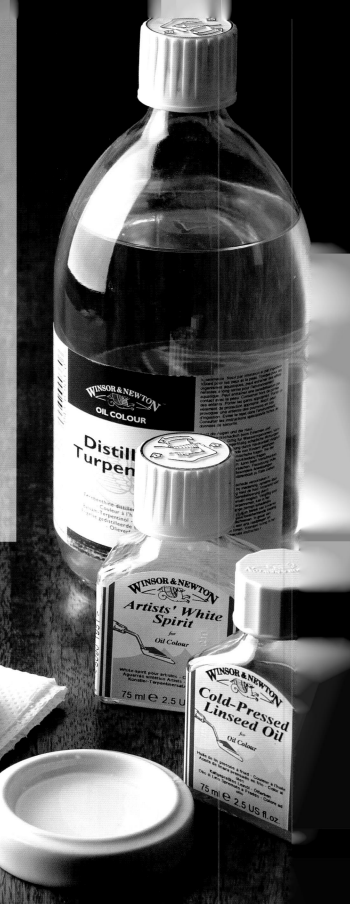

Tip

All artists have their solvent preferences for preparing oil paints, but the general rule is half linseed oil and half turpentine or white spirit. This should give you a useful mix for all your needs and keep your painting workable for at least a day or two.

Transferring the image

Transferring the image to your canvas could not be easier. Pull out the tracing you want to use from the front of the book. You will also be able to reuse the tracing several times.

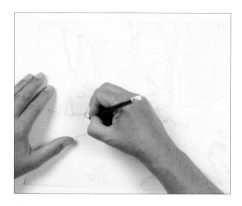

1 Place your tracing face-down on some scrap paper. Pressing quite heavily, go over the lines on the back using a 4B pencil. This is a section from the Bluebell Woods project on page 26.

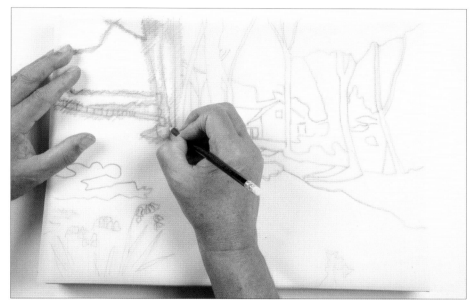

2 Place the tracing face-up on top of your canvas. Scribble vigorously over the lines.

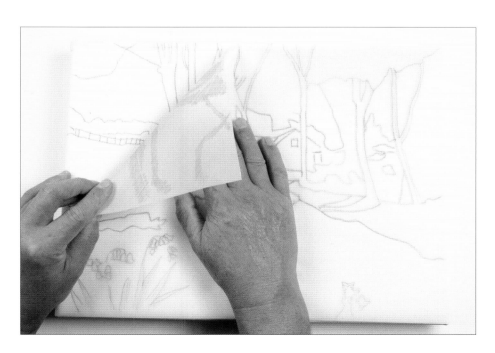

3 You can lift up the tracing as you work, to see how the transfer of the image is going. Continue scribbling over the lines until the whole tracing has been transferred, then remove the tracing. You may wish to reinforce any very faint lines.

Poppy Field

Poppies are an artists' favourite because of the immediate impact of complementary colours like red and green. I enjoyed redoing it for you and still love the distance you can get from the distant green, the blue of the background and the rich red of the poppies.

You will need

40 x 30cm (16 x 12in) linen stretched canvas

Colours: cadmium orange, titanium white, burnt umber, viridian, cadmium red, French ultramarine, lemon yellow, permanent mauve, alizarin crimson, sap green, Winsor red

Brushes: size 8 flat, size 4 flat, size 2 round, size 2 flat, size 1 round, fan brush

4B pencil

Linseed oil

White spirit

Kitchen paper

1 Transfer the image to your canvas, and dip some kitchen paper in a little linseed oil. Rub it gently over the canvas.

2 Use a size 8 flat to scrub a dilute mix of cadmium orange, titanium white and burnt umber over the fields as shown.

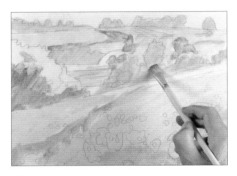

3 Add viridian to the mix and apply across the greenery to continue the underpainting.

4 Apply some dilute cadmium red to the outlined poppies and add some loose dots and strokes to the rear of the field. Paint the rooftop and background field details with the mix.

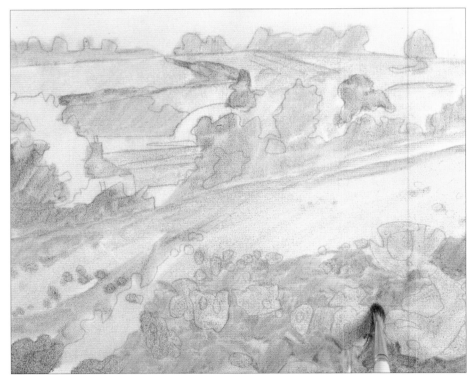

5 Add cadmium orange to the mix and block in some shading, then add a little French ultramarine for the shadows on the lower right.

6 Mix viridian and French ultramarine and use short strokes to add shading to the background and greenery.

7 Mix a pink from titanium white with a touch of cadmium red and block in the sky. Use the same mix on the rear of the poppy field and buildings.

8 Make a mix of lemon yellow and titanium white and use the size 4 flat to block in the light areas.

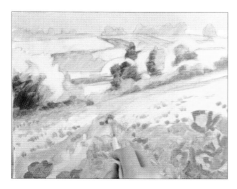

9 Apply neat cadmium red to the foreground poppies. Still using the size 4 flat, touch the brush lightly into the field to add the background poppies.

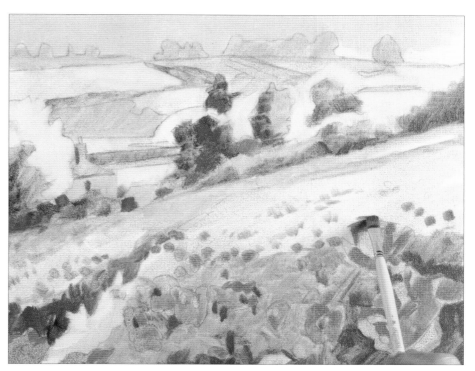

10 Mix viridian, cadmium red, French ultramarine and a little white to produce a strong, rich grey. Use this to block in the main areas of shadow.

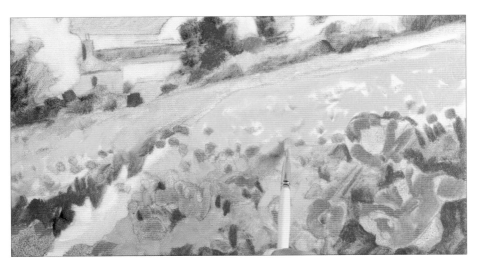

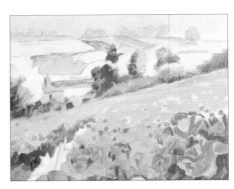

11 Apply a thick, strong mix of titanium white, cadmium orange and lemon yellow to the field, using the brush to draw round and reinforce the shapes on the canvas.

12 Add a touch of cadmium red to the mix and paint the rear part of the foreground field. Use it to add some sunlight to the trees and background.

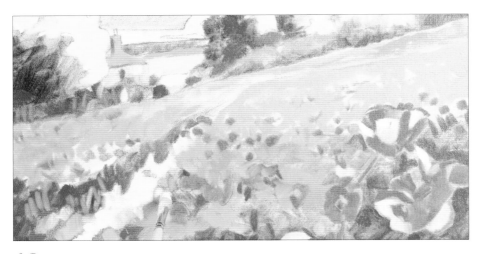

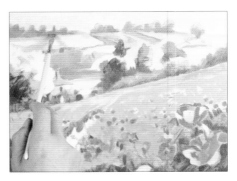

13 Use the pink mix (cadmium red and titanium white) to start the highlights on the foreground poppies and the house.

14 Add viridian to the pink mix and establish the highlights on the foliage. Add French ultramarine and permanent mauve to the mix and vary the tones.

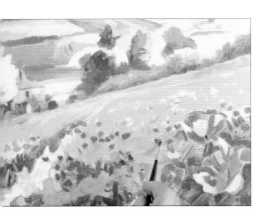

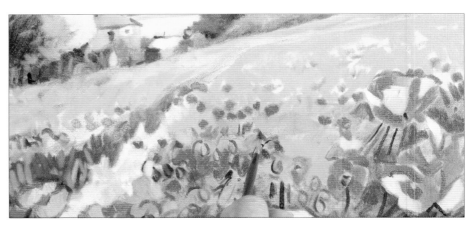

15 Switch to a size 2 round and use a mix of alizarin crimson and cadmium red to develop the poppies.

16 Paint in the details on the foreground, such as the poppy centres and corn stalks, using the tip of the size 2 flat and a mix of alizarin crimson, viridian and French ultramarine.

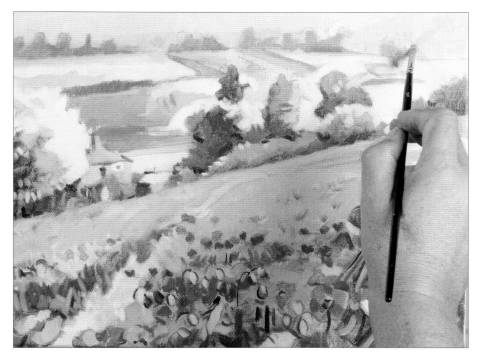

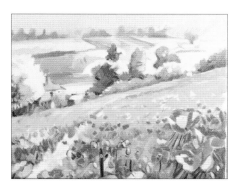

17 Mix lemon yellow, sap green and titanium white and use this to paint highlights across the foreground. Next, add more titanium white and a touch of French ultramarine and paint in distant trees on the horizon.

18 Mix titanium white with sap green and paint in green details across the foreground and middle distance.

19 Use tiny strokes of the brush to touch in poppies across the foreground. Use neat cadmium red at the front and blend it into the yellow further back.

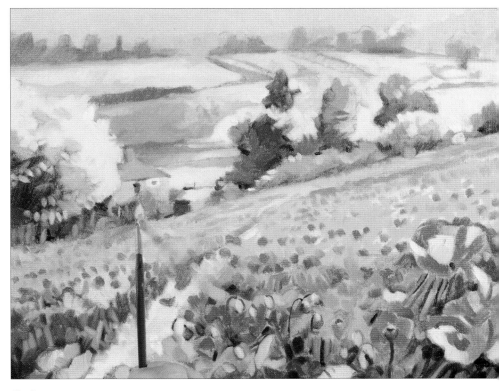

20 Mix sap green, viridian and titanium white and use this mix to overpaint the background fields to bring out the underpainting.

21 Make a dark mix of burnt umber, viridian and French ultramarine and use it to develop the darks across the bottom of the painting. Break up the mid-line with a mix of titanium white, cadmium red, cadmium orange and a little burnt umber.

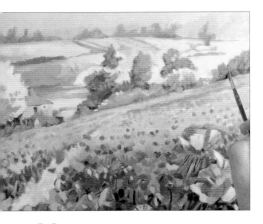

22 Reinstate the reds with cadmium red, then add touches of cadmium orange to them. This ensures that there is enough paint on the poppies when you come to blend them later. Similarly, add a mix of titanium white, French ultramarine and viridian to develop the midtones in the greens.

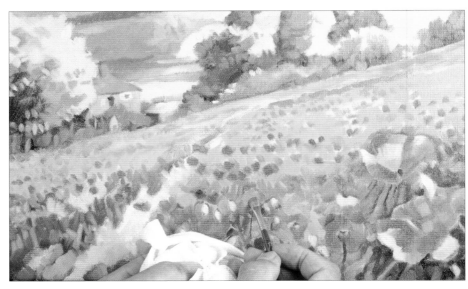

23 Now the tonal structure is in place, use a clean size 2 flat to begin taking the hard edges off the brushstrokes and to blend the areas of colour together. Do not blend the outside edges of shapes, and make sure that you keep your brush clean by wiping it on kitchen paper every so often.

24 Use the sharpened end of a brush to scratch away the paint from the canvas and detail the corn stalks and poppies.

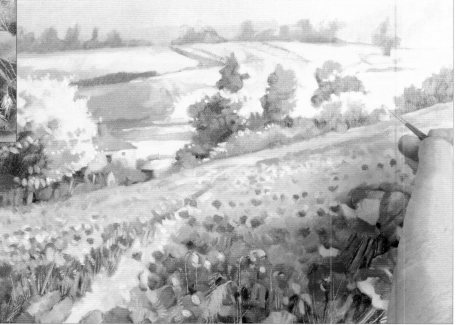

25 Do the same on the left of the picture, then use the size 1 round with a mix of lemon yellow and titanium white to re-establish the cornstalks and to detail the foreground. Re-establish the shapes of the trees and bushes with the same brush and mix.

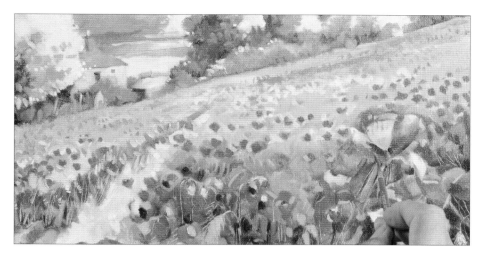

26 Add touches of Winsor red and alizarin crimson to the poppies and develop the reds and pinks across the painting by blending these colours in with the size 1 round. Vary the tints with touches of titanium white for variety.

27 Re-establish some darks in the foreground using the size 1 round and a mix of French ultramarine, viridian and alizarin crimson, then use a clean size 8 flat to knock away hard lines and soften the picture.

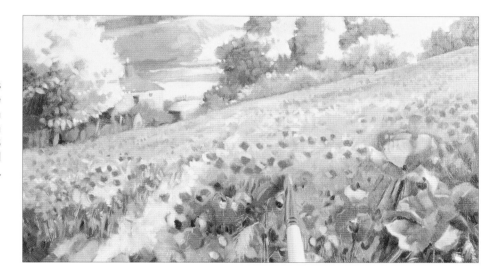

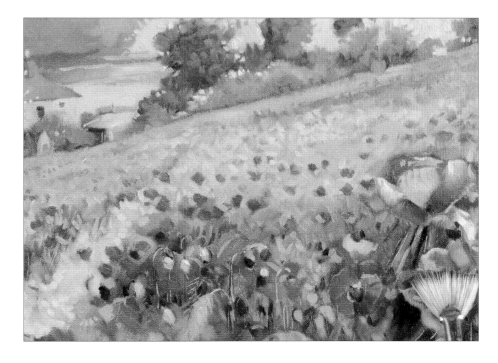

28 Add some final touches of a very light mix of lemon yellow and titanium white, then soften them away to finish the painting. Leave overnight and use a clean, dry fan brush to soften the foreground.

Overleaf

The finished painting.

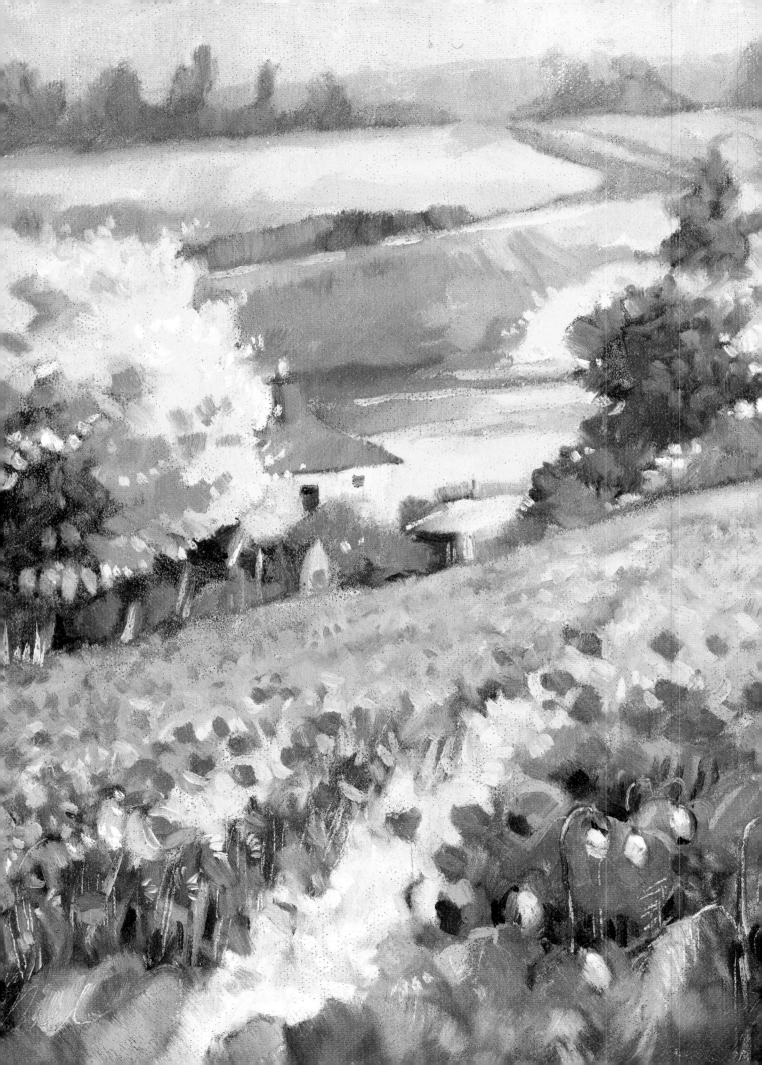

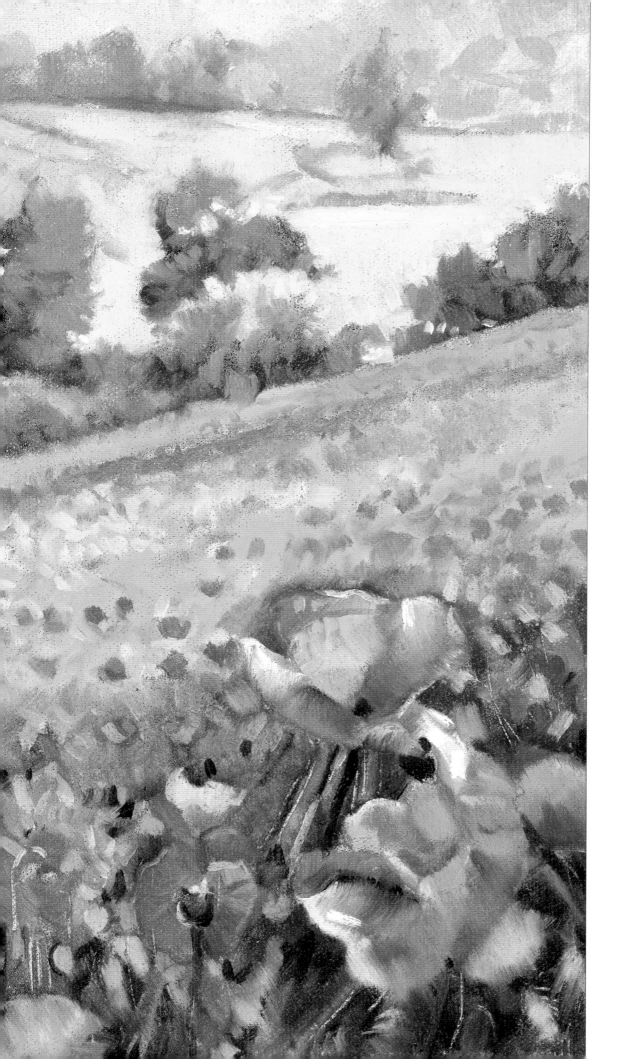

Spanish Doorway

Part of my village in Almeria, doorways like this are one of the reasons I live in Spain. With its sunshine and shadow, almost everywhere seems to be a composition waiting to be painted. Try to understand this painting's strong tonal structure and to get the sunshine lighting up the subject.

You will need

40 x 30cm (16 x 12in) linen stretched canvas

Colours: cobalt blue, titanium white, cadmium red, sap green, cadmium orange, viridian, French ultramarine, alizarin crimson, burnt umber, permanent mauve, lemon yellow

Brushes: size 8 flat, size 2 flat, size 4 flat, size 1 round

Linseed oil

White spirit

Kitchen paper

4B pencil

1 Transfer the image to your canvas, and spread a little linseed oil over it with a piece of kitchen paper.

2 Begin establishing the tonal underpainting by using the size 8 flat to drop in a dilute mix of cobalt blue and titanium white to the areas of shadow.

TRACING
3

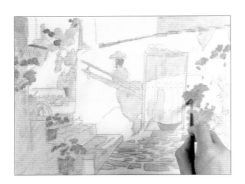

3 Switch to the size 2 flat and establish the red areas using dilute cadmium red.

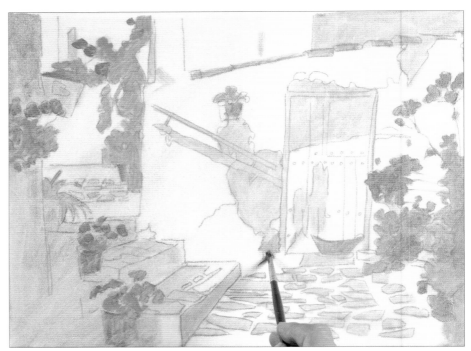

4 Similarly, use a green mix of sap green and titanium white to establish the green areas.

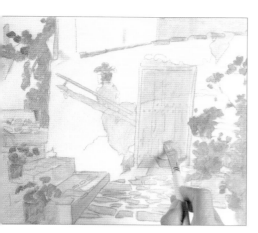

5 Using the size 8 flat, apply a dilute mix of cadmium orange and titanium white to the painting to create warm areas and the door.

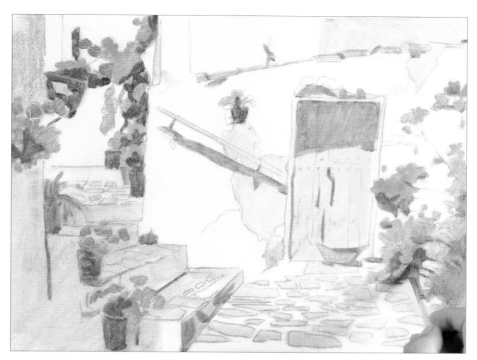

6 Switch to the size 4 flat and use a dilute mix of viridian, French ultramarine and alizarin crimson to establish the darks.

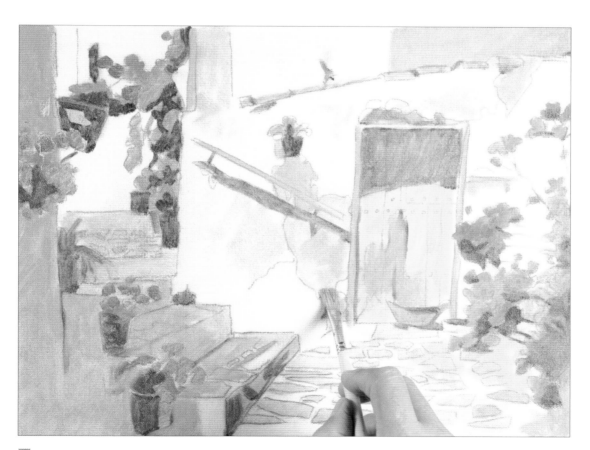

7 Reinforce the shadow areas and suggest light shading on the door and walls with a less dilute mix of cobalt blue and titanium white. This completes the underpainting.

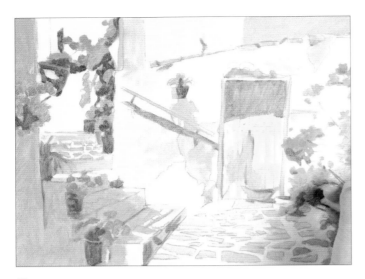

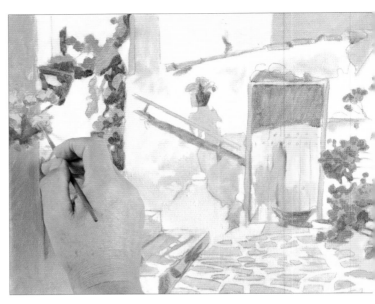

8 Block in the walls with a fairly thick mix of titanium white. Vary the hue with tiny touches of cobalt blue and cadmium red to suggest the different whites. Use a size 2 flat to block in large areas, and a size 1 round for smaller areas and details.

9 Use thick cadmium red to develop the flowers and pots with the size 1 round, then add some titanium white to the red and create highlights.

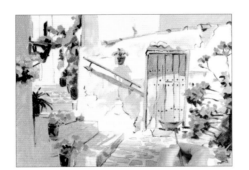

10 Develop and texture the darks with a mix of burnt umber, French ultramarine, viridian and alizarin crimson and the size 1 round.

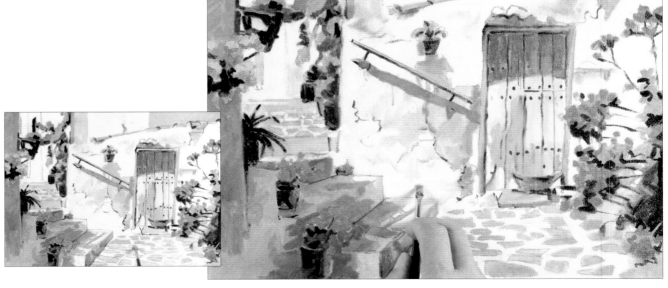

11 Use a permanent mauve, viridian and titanium white mix with a size 2 flat to develop the shadow areas (see inset), then add a little more titanium white and add subtle variations to both the shadow and white areas.

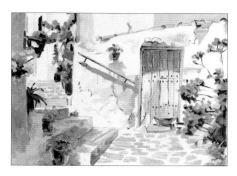

12 Mix a strong green from viridian and titanium white, and use it to reinforce the plants.

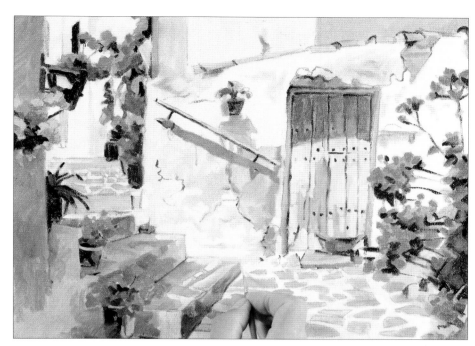

13 Add cadmium orange to a pink mix of cadmium red and titanium white. Use the size 1 round to carefully develop the section of the door in sunlight. Use the same mix to vary the white walls and paint the rail.

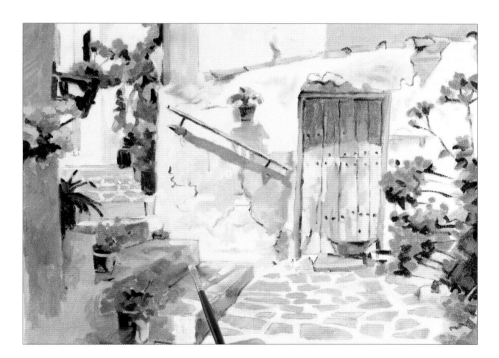

14 Dull down a cadmium orange and titanium white mix by adding a touch of viridian. Develop the door with the size 2 flat. Touches of the same mix can be used on areas such as the flowers, pots, tiles and shadows.

15 Mix French ultramarine and cobalt blue with a little burnt umber and develop the dark part of the door. Add some neat burnt umber to vary it.

21

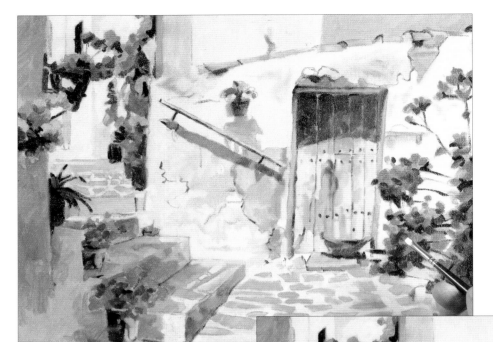

16 Shade the red flowers with a mix of viridian and a tiny touch of titanium white. Add alizarin crimson to vary the hue.

17 Continue developing the tonal contrast on the flowers by adding touches of a cadmium orange and cadmium red mix with the size 1 round. The same colour can develop the tiles above the door.

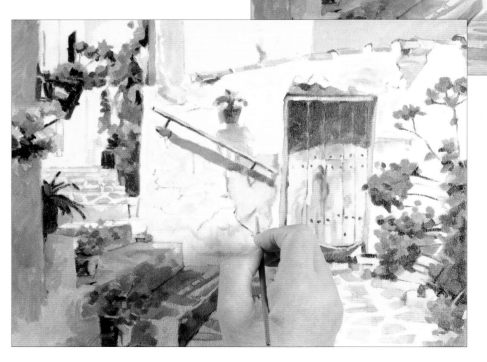

18 Use pure titanium white to develop the white areas. This stage should be used to re-draw any areas that have become unintentionally fuzzy or indistinct during the blending. Add touches of lemon yellow and sap green to the white for the area on the left of the door.

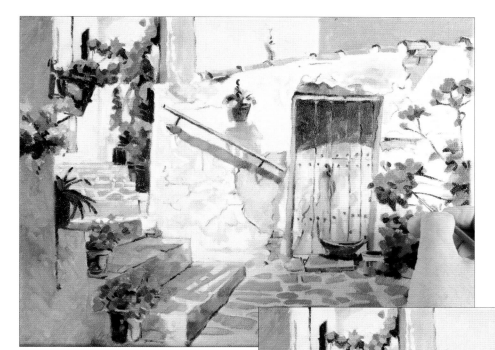

19 Use the size 2 flat with a mix of cobalt blue and titanium white to reinforce the sky and vary the shadows, then use the size 1 round to draw in and re-emphasise details with a dark mix of burnt umber, French ultramarine and viridian.

20 Add light green touches with a mix of lemon yellow and titanium white, using touches of viridian and cobalt blue to vary the hue.

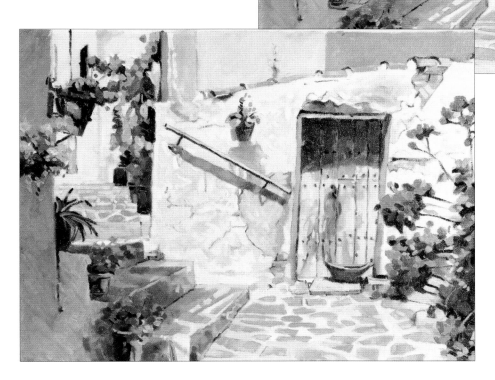

21 Use the size 2 flat to add touches of the dark mix across the painting, particularly on the rail and door. Use titanium white to repeat the process and balance any tonal shifts. Finally, add mid-tone touches of permanent mauve to the flowers.

Overleaf

The finished painting.

23

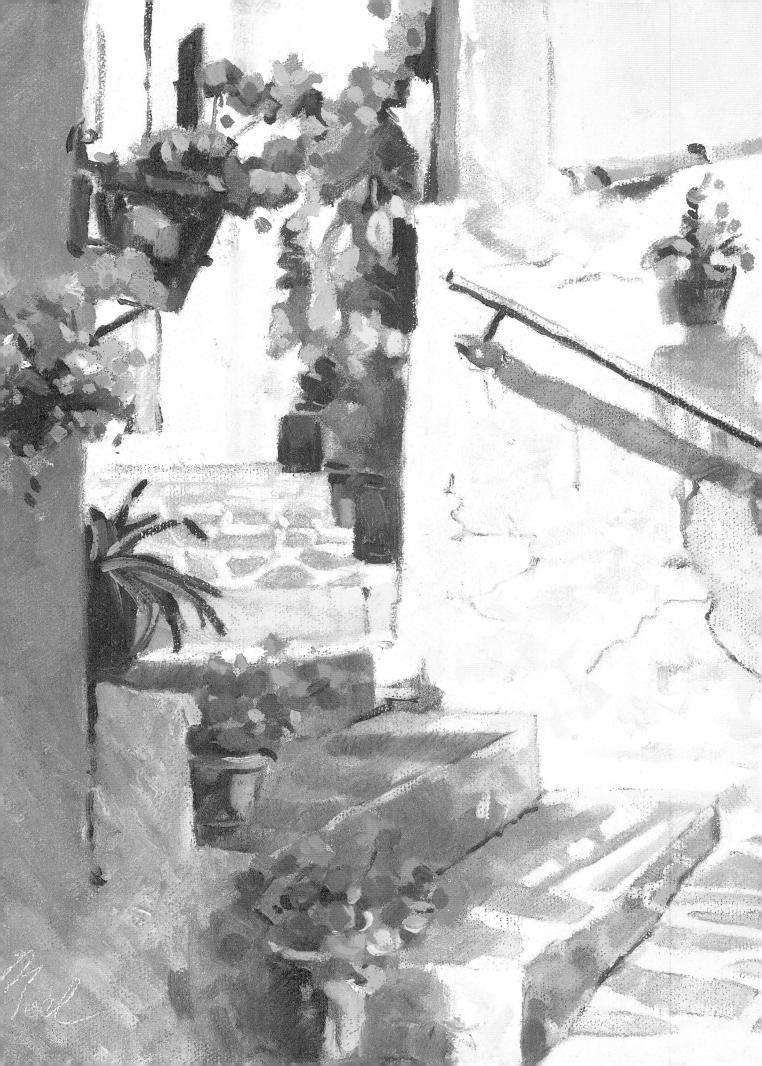

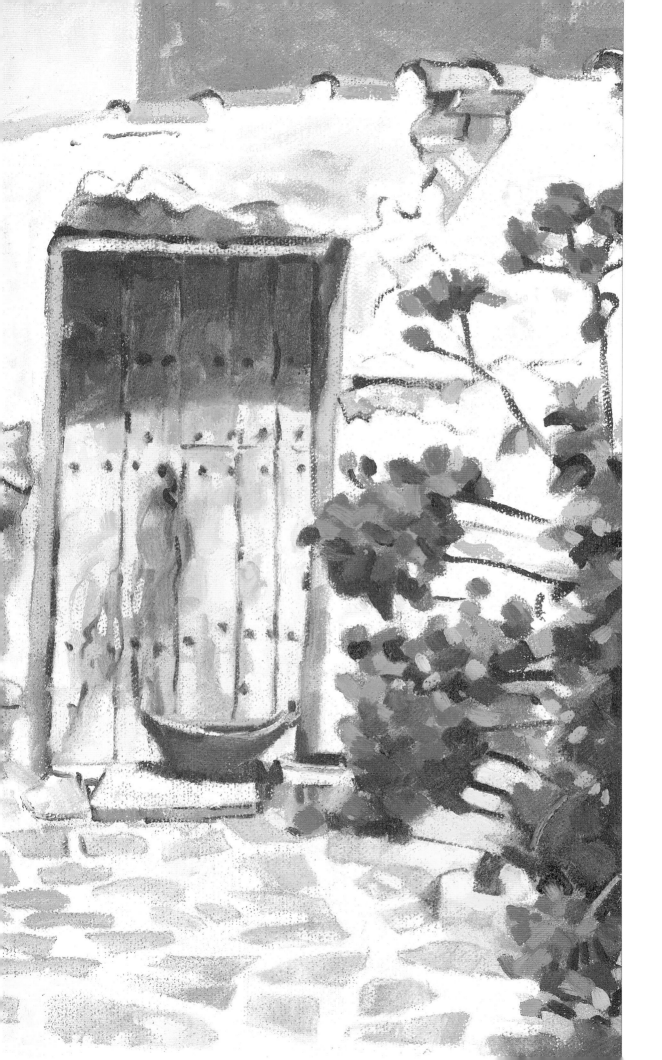

Bluebell Woods

This view is of my home in England and in the spring the wild garden is covered with bluebells. I make no apologies for including it as an example of landscape painting because it represents to me the epitome of the peace and natural beauty of the English landscape.

During the original painting of this scene I was sitting next to an active badger sett and was treated to many a visit by these inquisitive animals. Happy painting.

TRACING
4

You will need

40 x 30cm (16 x 12in) linen stretched canvas

Colours: lemon yellow, viridian, titanium white, cadmium red, French ultramarine, alizarin crimson, cobalt blue, cadmium yellow, sap green, permanent mauve, burnt umber, cadmium orange

Brushes: size 8 flat, size 2 flat, size 4 round, size 1 round, fan brush

Linseed oil

White spirit

Kitchen paper

4B pencil

1 Transfer the tracing to canvas, and rub a little linseed oil into it with a sheet of kitchen paper.

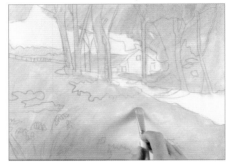

2 Use the size 8 flat to apply a very dilute green mix of lemon yellow and viridian across all of the picture except for the sky, path and buildings.

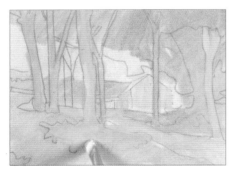

3 Apply a dilute pink mix of titanium white and cadmium red to the building and path, then apply the same mix on to some of the foreground trees as shown.

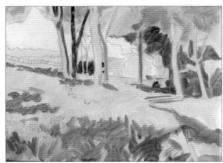

4 Apply a very dilute dark mix of French ultramarine, alizarin crimson and viridian to the areas in shadow. Add viridian for a deep green mix and apply to the foliage.

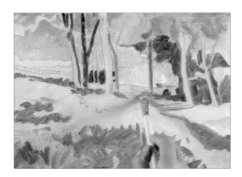

5 Make a blue mix of cobalt blue and titanium white and paint the sky. Add a touch of alizarin crimson to the mix and shade the path in the distance.

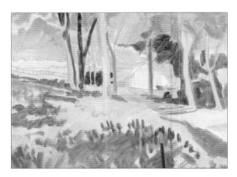

6 Use the size 2 flat with dilute cobalt blue to suggest where the areas of bluebells will go. This completes the underpainting.

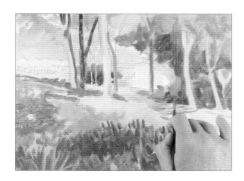

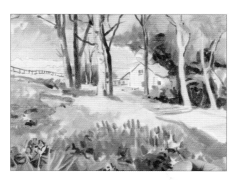

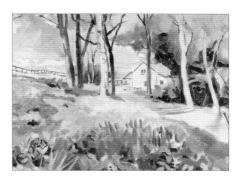

7 Mix viridian with lemon yellow to make a fairly thick and strong green and begin to develop the undergrowth.

8 Make a dark mix from alizarin crimson, French ultramarine and viridian and use the size 4 round to paint in the fence, background trees and other dark details.

9 Use the size 2 flat with a thick mix of cadmium yellow and sap green to break up the plain areas of foliage and add variety to the greens. Add titanium white to the mix and repeat the process, further developing the greens.

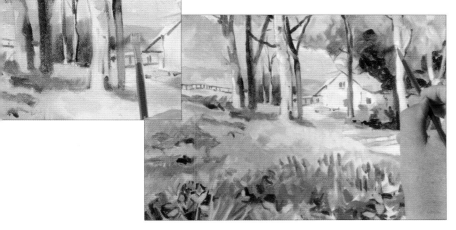

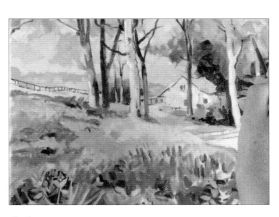

10 Add more sap green, titanium white and a touch of cadmium red to make a pale green-grey with which to paint the distant treeline (see inset). Use the same mix to add subtle notes to the overall picture, then add more titanium white and cadmium red to develop the trunks of the ash trees and the house.

11 Add a little French ultramarine to titanium white and block in the sky. Dab 'sky windows' into the foliage, then use the same mix to add touches to the bluebells.

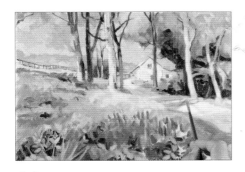

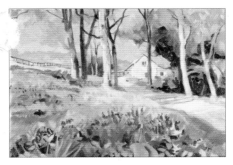

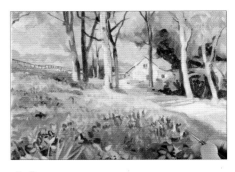

12 Add cadmium red and more titanium white to the blue mix to make a muted pink. Use this to develop the buildings and vary the undergrowth and path.

13 Switch to the size 4 round and use a mix of cobalt blue and permanent mauve to add touches of detailing to the bluebells. Add titanium white to the mix and develop the bluebells further.

14 Add sap green and cadmium yellow to the muted pink on your palette to make a neutral green. Use a size 4 round to link the various undergrowth areas by dabbing short strokes of the mix here and there.

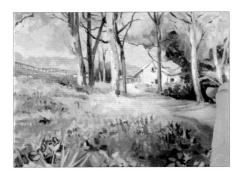

15 Warm the trees with a mix of burnt umber, cadmium orange and French ultramarine. Switch to a size 1 round and detail the building, then add branches in the background with the same mix.

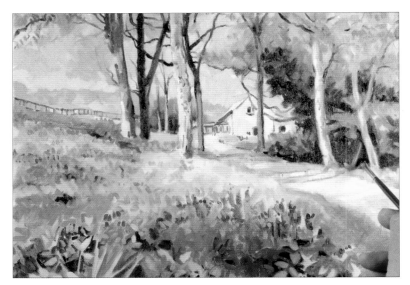

16 Make a green mix of viridian, sap green, cadmium yellow and cadmium red, and use a size 2 flat to apply short strokes across the green areas of the painting. Add still darker areas with an alizarin crimson and viridian mix.

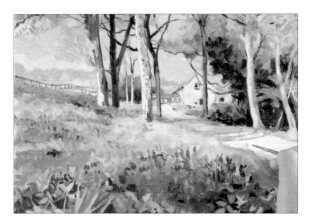

17 Add tiny touches of sap green and cobalt blue to titanium white and use the size 1 round to add highlights across the painting, particularly on the trees.

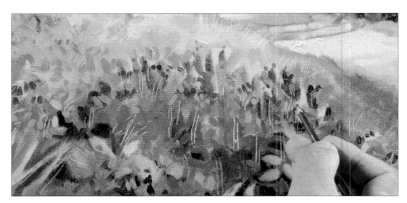

18 Use the sharpened end of a brush to scratch out stems, stalks and branches in the foreground.

19 Scratch out branches in the trees, then add a little viridian to cadmium yellow and touch leaves in to the foliage using the size 1 round brush.

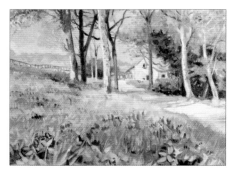

20 Add a little alizarin crimson to viridian and use the dark mix to touch in further leaves and foliage. Develop the undergrowth and foliage with the various green mixes on your palette.

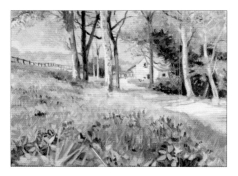

21 Add some brown across the painting with a rich mix of cadmium orange and burnt umber. Vary the mix with titanium white.

28

22 Using the side of the fan brush (see inset), blend any hard edges to soften the painting.

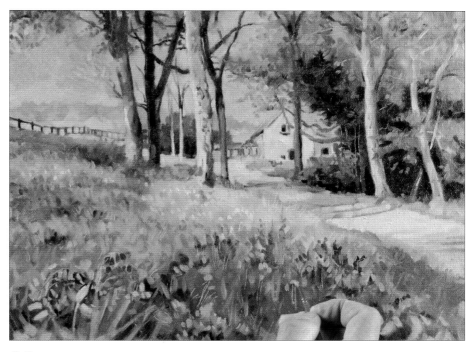

23 Reinstate the bluebells with the blue mixes on your palette, and use the pink mix (cadmium red and titanium white) and a yellow mix (lemon yellow and titanium white) to add dappled sunlight.

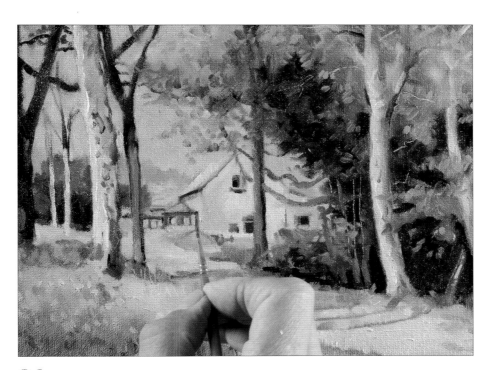

24 Using the size 1 round to detail the building, applying thick titanium white for highlights, and a dark brown mix of alizarin crimson, burnt umber and French ultramarine for shading.

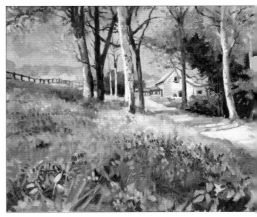

25 Tighten the bluebells once more, and make any final tweaks you feel necessary using the mixes on your palette.

Overleaf

The finished painting.

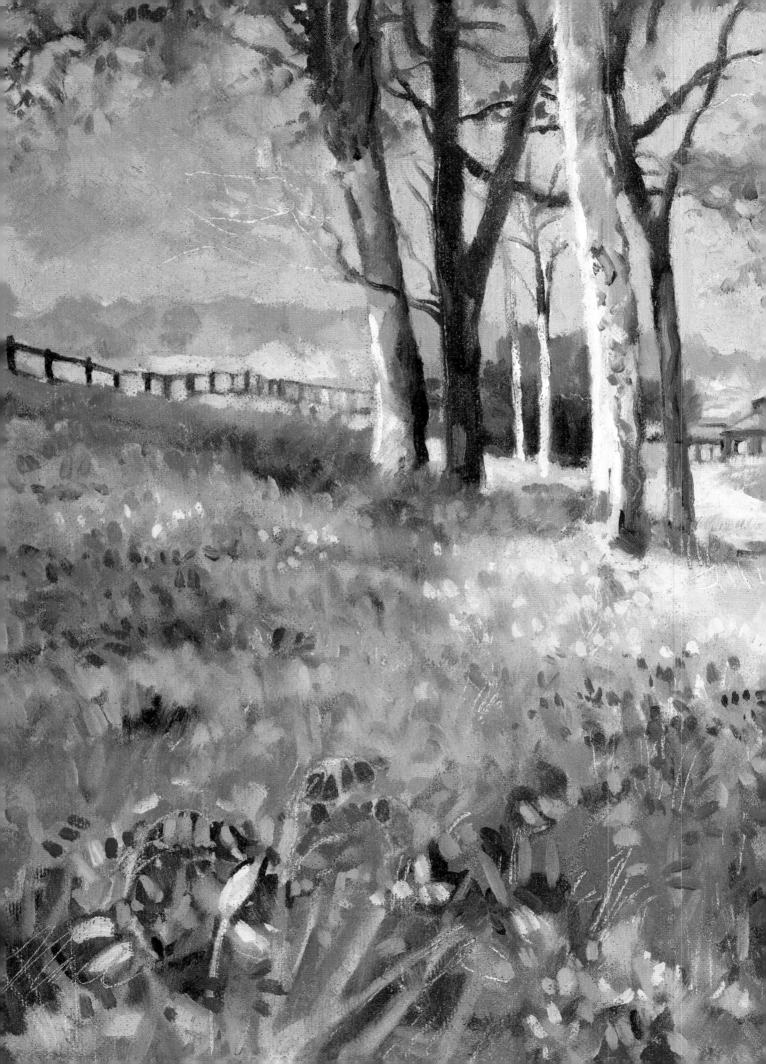

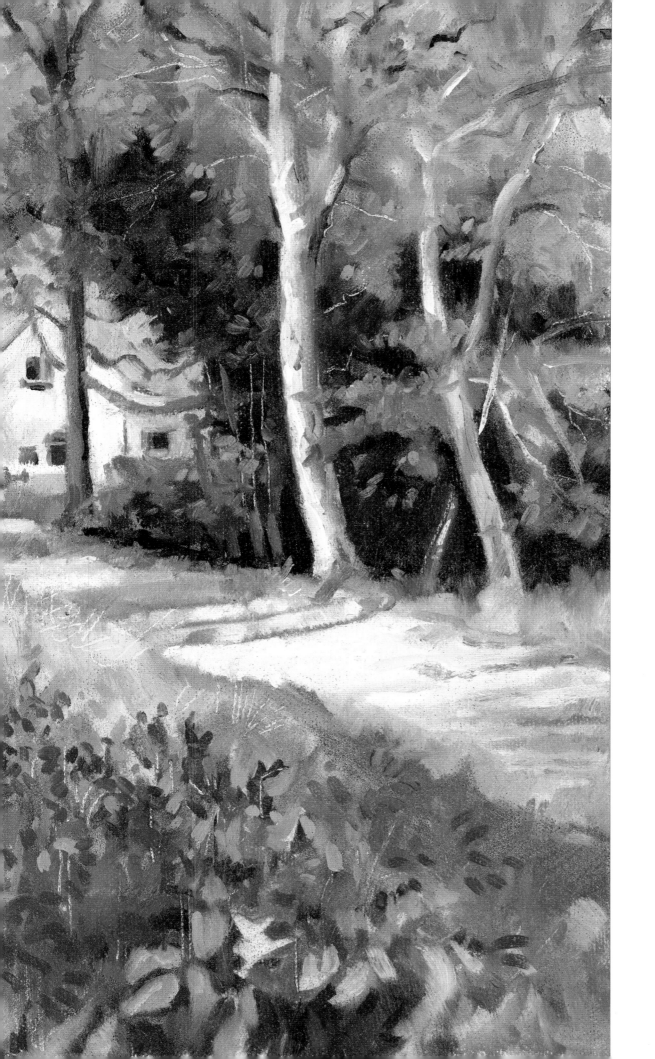

River Landscape

It is hardly believable that this tranquil river is in an industrial estate near London. It was not far from my gallery and I have often painted it in its many moods. I hope you enjoy copying this sketch in its midsummer colours for it is an ideal romantic subject for the artist as well as a reminder of a good morning's work in front of the easel.

TRACING

5

You will need

30 x 40cm (12 x 16in) linen stretched canvas

Colours: sap green, permanent mauve, French ultramarine, cadmium orange, lemon yellow, titanium white, burnt umber, cadmium red, viridian, sap green, cobalt blue, alizarin crimson

Brushes: size 8 flat, size 4 flat, size 2 flat, size 1 flat, size 1 round

Linseed oil

White spirit

Kitchen paper

4B pencil

1 Transfer the image to your canvas, and dip some kitchen paper in a little linseed oil. Rub it gently over the canvas.

2 Apply dilute sap green to the main areas of foliage with the size 8 flat to begin the underpainting.

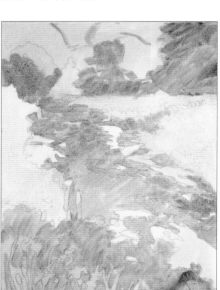

3 Add some midtone areas with a dilute mix of permanent mauve and French ultramarine.

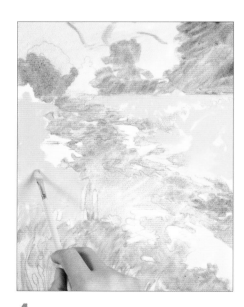

4 Make a less dilute mix of cadmium orange, lemon yellow and titanium white. Use the size 4 flat to block in the grasses.

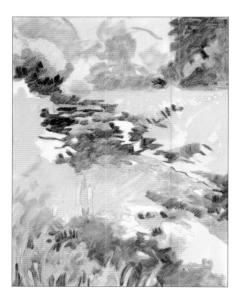

5 Add the dark tones with a size 2 flat and a dilute mix of French ultramarine, permanent mauve, viridian and burnt umber.

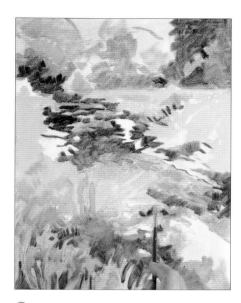

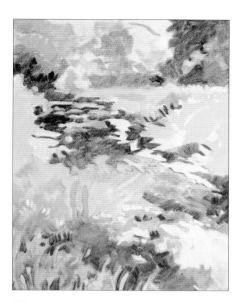

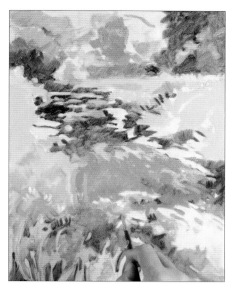

6 Apply a dilute mix of cadmium red and titanium white to add pink hues.

7 Add fairly thick titanium white to re-draw the water. You should aim to pick up a little of the underpainting colour.

8 Make a fairly thick mix of permanent mauve, French ultramarine and titanium white and use it to paint the river. Add viridian to vary the hue.

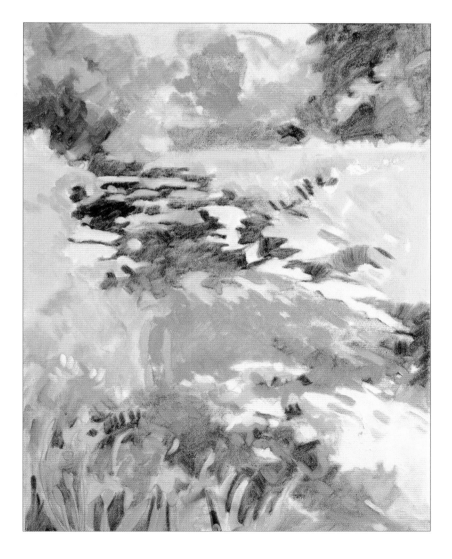

9 Use a size 1 flat to paint the iris stalks in the foreground with sap green and a touch of viridian. Use the same mix to add green touches to the overall picture.

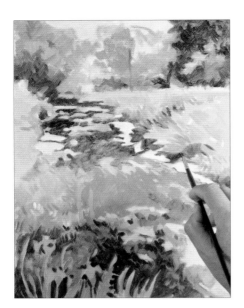

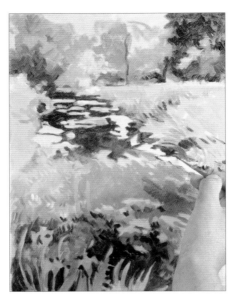

10 Use a thick mix of viridian with French ultramarine and permanent mauve to develop the darks. Vary the proportions across the painting.

11 Switch to the size 1 round and use undiluted titanium white to re-draw the river highlights; then use a permanent mauve and French ultramarine mix to re-draw the river shadows

12 Build up the paint structure on the grasses with short strokes of the size 2 flat and lemon yellow with a touch of cadmium orange. Allow the brush to do the work in building up texture.

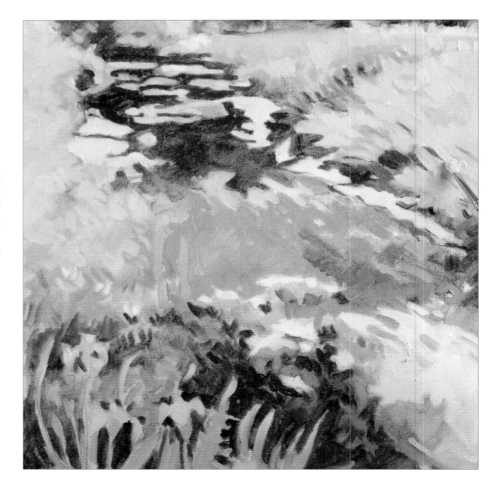

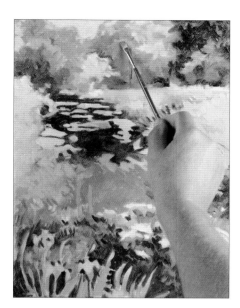

13 Build up the trees in the same way, using a mix of viridian and lemon yellow and the dark mix on your palette for the shading.

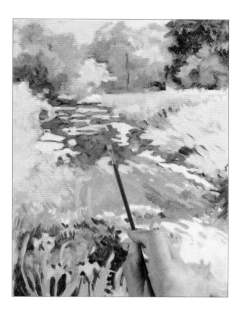

14 Make a mix of permanent mauve, French ultramarine, viridian and titanium white. Use this with subtle strokes to soften and texture the river in shadow. The same mix can be used on the grasses to add interest.

15 French ultramarine and titanium white should be used to build up the foreground section of the river. Vary the hue with touches of cobalt blue and permanent mauve.

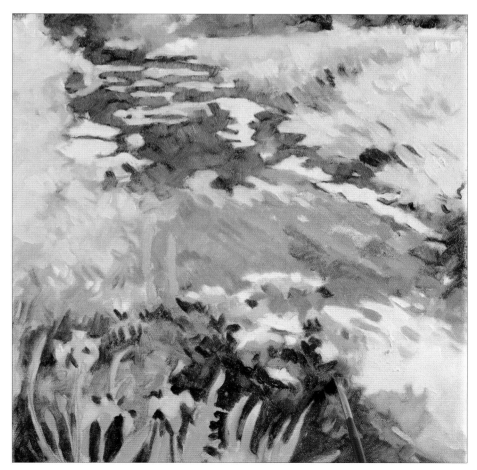

16 Using the size 1 round, develop and re-draw the foreground flowers and river with pure titanium white (see inset). Contrast this and maintain the tonal balance by adding touches of the dark mix (French ultramarine, alizarin crimson and viridian).

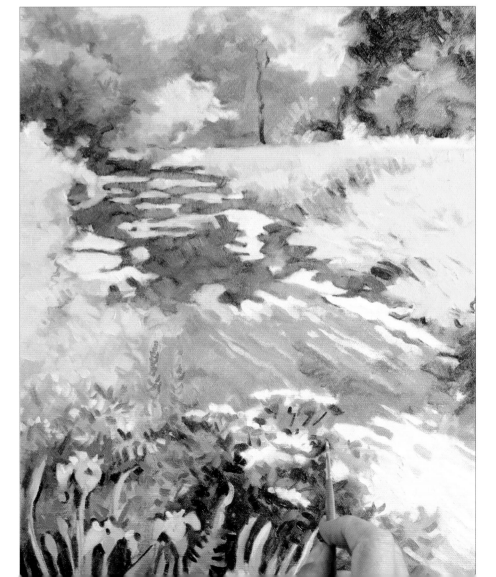

17 Detail the flowers in the foreground with a mix of cadmium red and permanent mauve. Use lighter touches for the pink areas in the rest of the painting.

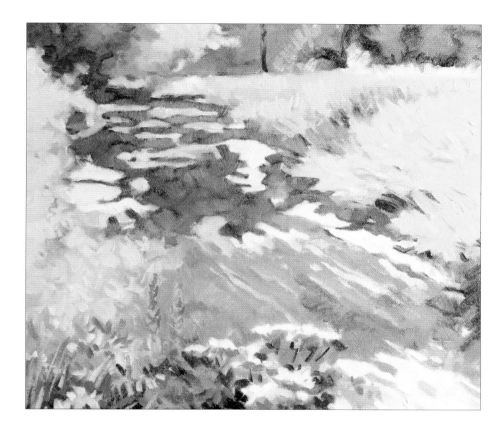

18 Add titanium white to a mix of lemon yellow and cadmium orange. Use this to texture the grassy areas; and add light strokes in the foreground to lift the whole area.

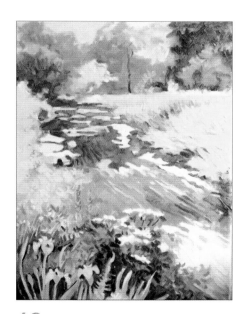

19 Suggest weeds and movement in the river with subtle lines of a French ultramarine and permanent mauve mix. Add touches of viridian to vary the colour. Similarly, vary the foliage with touches of an alizarin crimson and titanium white mix.

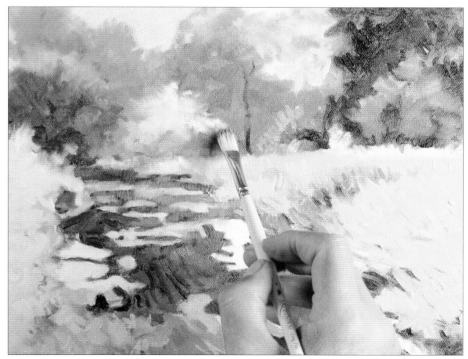

20 With the colour in place, use a clean, dry, size 4 flat to soften the background trees and foliage to remove hard areas and create an illusion of distance.

21 Gradually soften the rest of the painting in the same way. The aim of softening is to smudge some of the thicker brushstrokes together. Only the paint on the canvas is used, and it is important to keep your brush clean and dry, so wipe it often on kitchen paper.

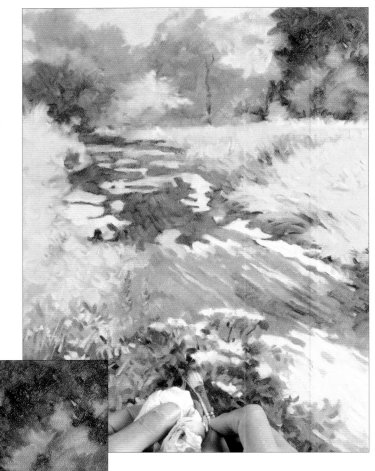

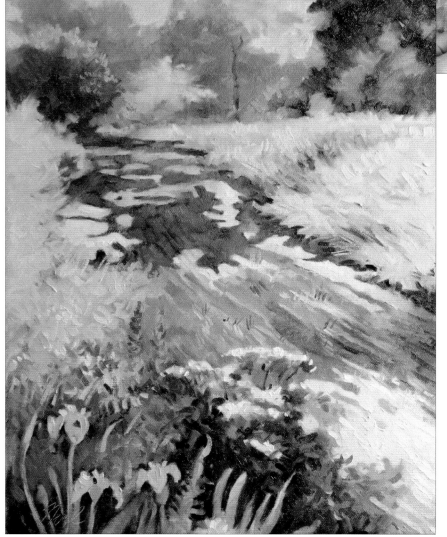

22 Use the size 1 round and the mixes on your palette to reinstate any details that you feel necessary. Refine any alterations by softening with the fan brush.

Opposite

The finished painting, reduced in size.

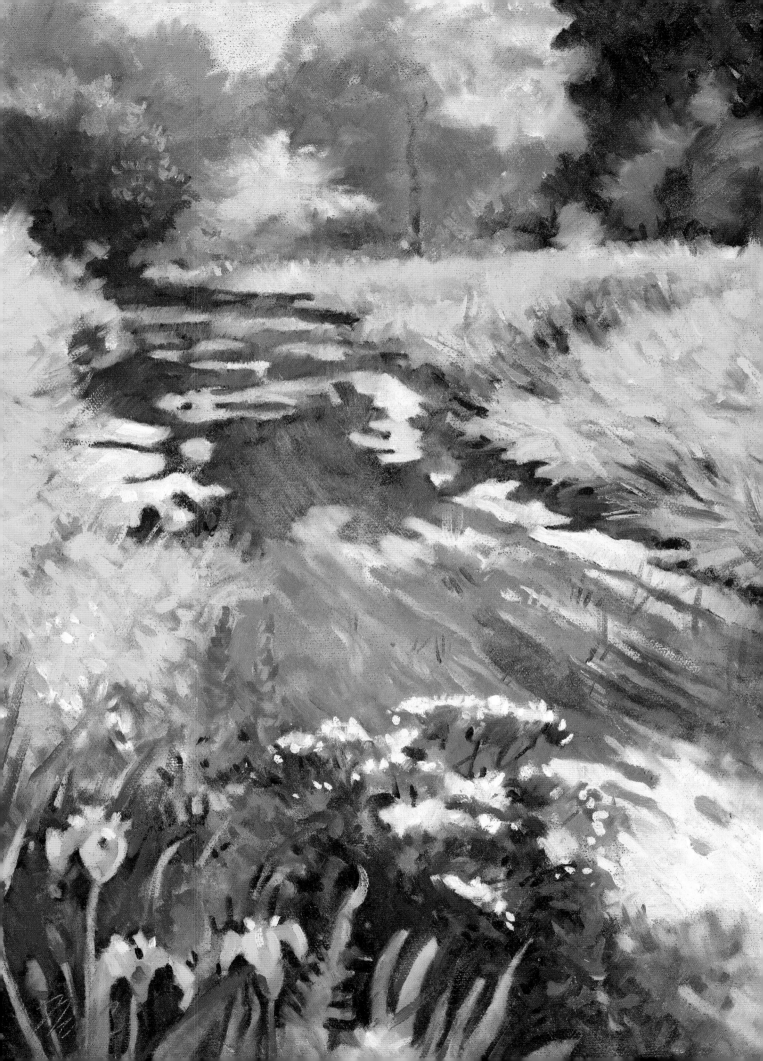

Harbour Fishing Boats

This Cornish harbour does not seem to have changed for centuries: these boats are still worked by lobster and crab fishermen today.

A grasp of perspective and an understanding of form are essential in painting complicated boat shapes, so using the tracing will be a great help to you.

You will need

30 x 40cm (12 x 16in) linen stretched canvas

Colours: cobalt blue, sap green, permanent mauve, cadmium orange, titanium white, burnt umber, French ultramarine, viridian, alizarin crimson, cadmium red, lemon yellow

Brushes: size 8 flat, size 4 flat, size 1 round, size 4 round, size 2 flat

Linseed oil

White spirit

Kitchen paper

4B pencil

TRACING

6

1 Transfer the image to your canvas, and dip some kitchen paper in a little linseed oil. Rub it gently over the canvas.

2 Make an extremely dilute mix of cobalt blue, and use the size 8 flat to block in the sky and harbour.

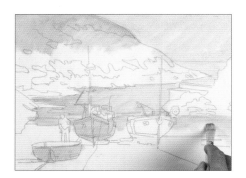

3 Dilute sap green and block in the top of the hill and the foreground areas shown.

4 Add permanent mauve to the dilute cobalt blue and block in the rocks and shadows.

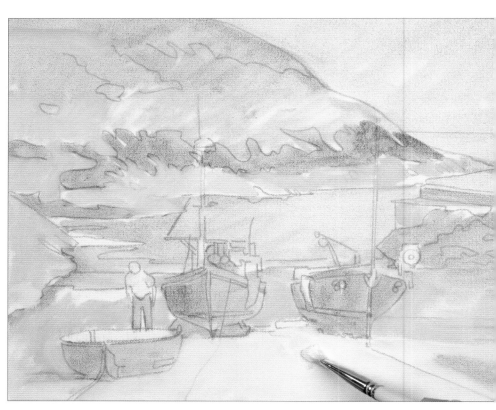

5 Mix permanent mauve with cadmium orange and titanium white. Use this sandy mix to paint in the lighter areas shown. Start in the distant background of the painting and add more titanium white as you advance. This completes the initial underpainting.

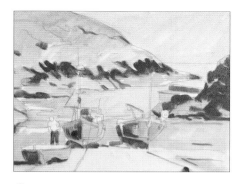

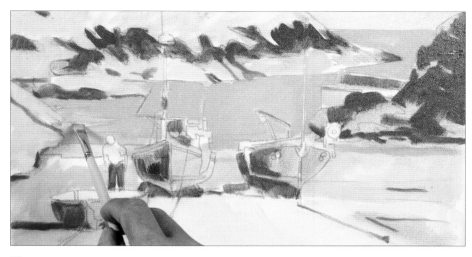

6 Switch to the size 4 flat, and mix permanent mauve, burnt umber, French ultramarine and titanium white to make a strong, rich grey. Use this to develop the tonal structure of the underpainting by adding dark areas.

7 Mix cobalt blue and titanium white, then add a touch of viridian. Still using the size 4 flat, paint in the sea.

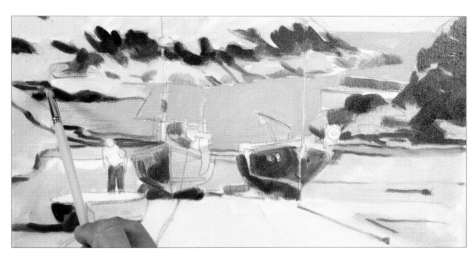

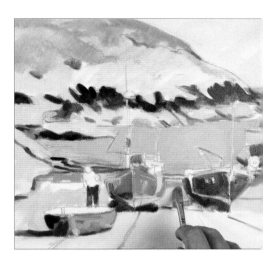

8 Use French ultramarine to paint the right-hand boat, blending the colour with the tonal grey already there. Next, add alizarin crimson and burnt umber to the French ultramarine and add deeper tones across the whole picture.

9 Mix viridian with titanium white and paint the acid tones on the left-hand boat. Blend the colour in across the rest of the painting.

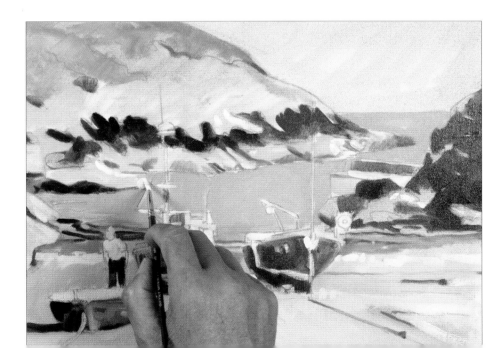

10 Use the size 4 round to draw in touches of pure titanium white for highlights.

11 Add touches of contrasting cadmium red to the left-hand boat using the size 4 round.

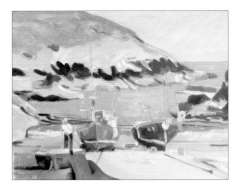

12 Mix burnt umber with titanium white and use this to redraw areas of sand and rocks, and to add skintones to the figure.

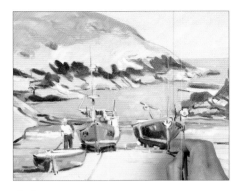

13 Switch to the size 1 round and use a dark mix of French ultramarine and burnt umber to refine the structure of the image.

14 Make a grey-green mix of titanium white with touches of viridian, alizarin crimson and cobalt blue. Use this thick mix with the size 8 flat to create bold tonal statements across the rocks and to build up paint texture. Add sap green and viridian to the mix and develop the greenery on the hill.

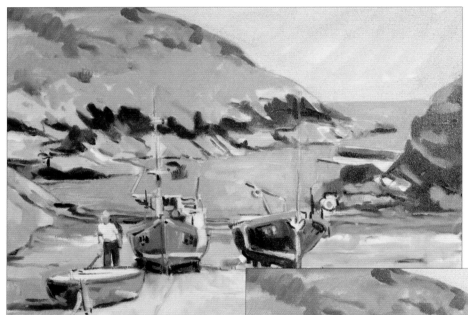

15 Add darker tones to the sea with a mix of French ultramarine, viridian and smaller amounts of titanium white and permanent mauve. You can use small amounts of the same colour on the background hills to develop the texture.

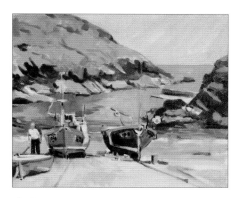

16 Mix viridian, burnt umber, French ultramarine and alizarin crimson to make a very dark mix. Establish dark tonal areas in the shadows using the size 4 round.

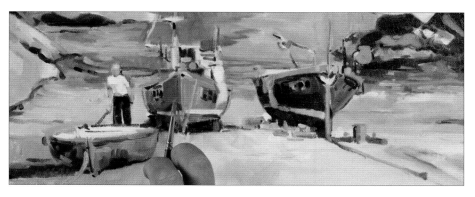

17 Paint the winder on the right-hand boat and water details in the foreground with a mix of titanium white and cobalt blue. Add viridian to make a great contrasting colour for ripples at the shoreline and highlights on the green boat.

18 Hold the size 8 across the horizon and draw the size 4 across it to make a straight line with the titanium white and cobalt blue mix.

19 Use the mixes on your palette to develop the colours and tones across the whole painting, then use pure titanium white to detail the boats and add highlights.

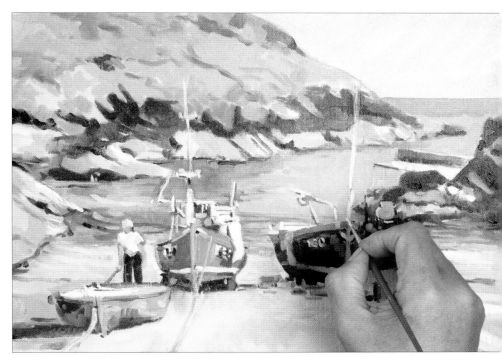

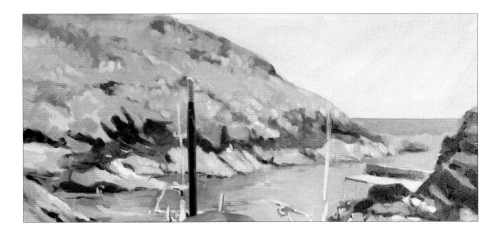

20 Use short, controlled strokes of the size 2 flat to break up the hill, adding touches of the various mixes and highlights of a lemon yellow and titanium white mix.

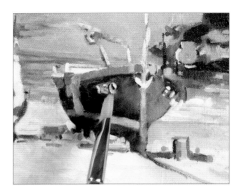

21 Using a clean, dry size 8 flat, carefully blend together the colours on the right-hand boat, merging the paint on the canvas to avoid obvious 'lumps' of colour.

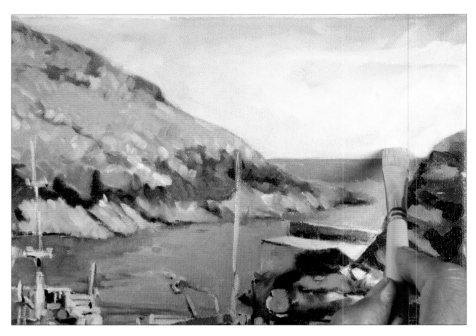

22 Blend the other boats in the same way, then paint in the sky with a mix of viridian and titanium white. Start from the top and work down to the horizon, adding more titanium white as you progress

23 Add in the deepest tones on the rocks using the size 2 flat with a mix of alizarin crimson, French ultramarine and viridian.

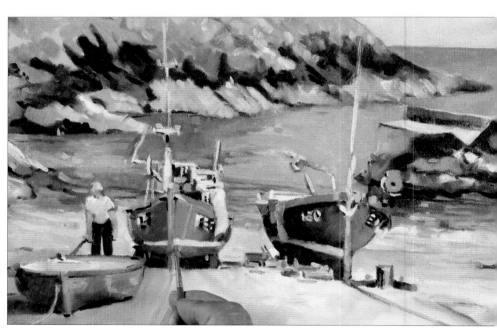

24 Switch to the size 1 round and use the same mix to develop the details, then add pure cadmium red to the bottom of the central boat.

25 Refine the foreground shapes with a thick pale mix of titanium white, cadmium yellow and a touch of cobalt blue, using the size 2 flat to texture the beach and tighten the surrounding shapes with negative painting.

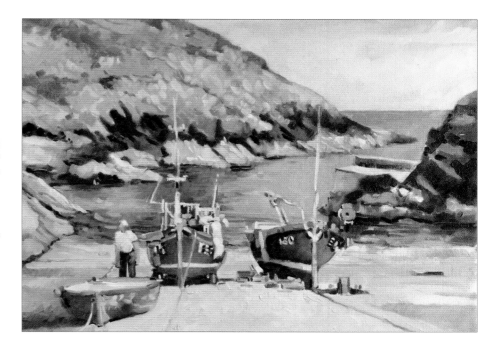

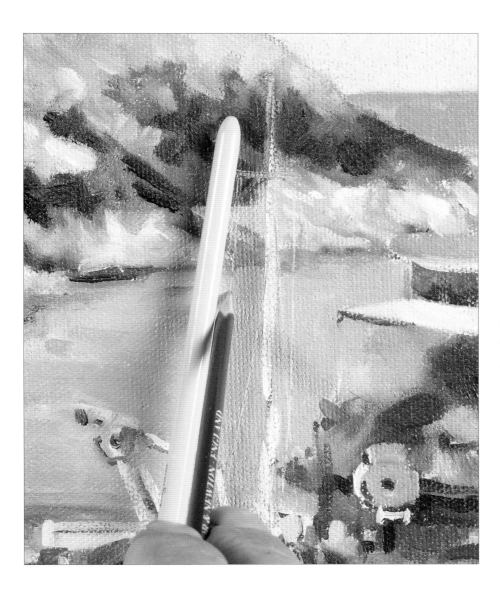

26 Allow the paint to dry overnight, then hold the size 8 flat against the masts as shown and use the sharpened end of a brush to scratch out the rigging.

Overleaf

The finished painting.

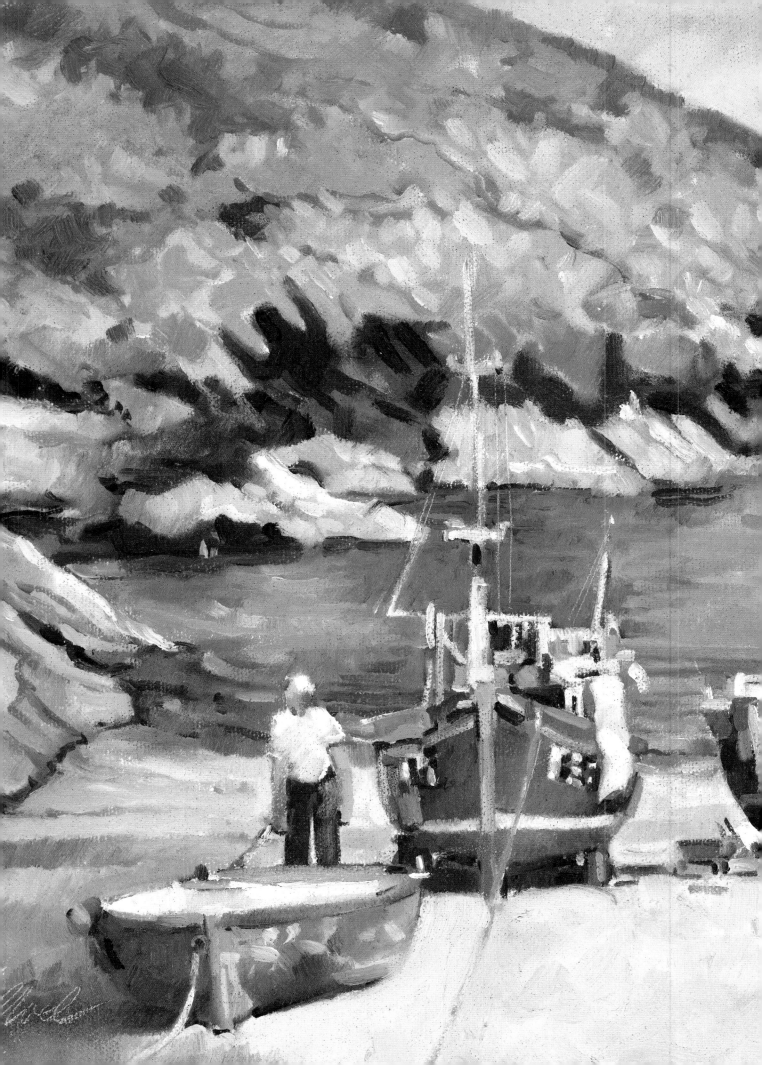

Index

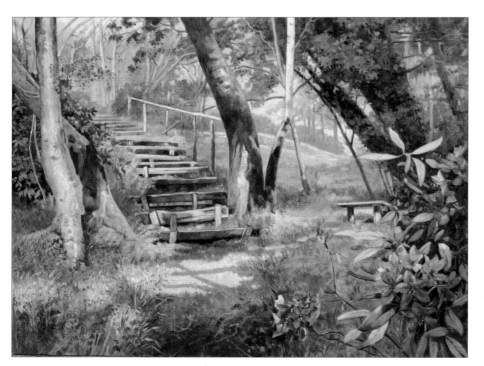

Rhododendron Steps

100 x 65cm (39½ x 25½in)

This, like the Rhododendron Bridge painting (see page 3), is another image taken from several photographs and put together to form the painting. The rustic steps form a focal point, leading the eye into the picture, and I have used their image several times in other compositions. The rhododendron and bluebell information was from specimens taken from life.